SISTERS

SISTERS

First Edition. Second Printing.

Copyright © Hoxton Mini Press 2017.
All rights reserved.
All photographs © Sophie Harris-Taylor.

Introduction and stories by
Emma Finamore.

Design by Carter Studio.
Sequence by Sophie Harris-Taylor
and Hoxton Mini Press.

A CIP catalogue record for this book is
available from the British Library.

ISBN 978–1–910566–28–2

First published in the United Kingdom
in 2017 by Hoxton Mini Press.

To order books, collector's editions and
signed prints please go to:
www.hoxtonminipress.com

SISTERS

Sophie Harris-Taylor

HOXTON MINI PRESS

INTRODUCTION

Few bonds run as deep as those between sisters, and few relationships are quite as close or complex. Maybe it's because of this—and society's preoccupation with female faces and forms—that sisters can be found in photography and art throughout history.

The Brown sisters were famously photographed by Nicholas Nixon every year between 1975 and 2014, in luminous black and white. Throughout his series, we watch the women age and experience the endurance of sisterhood, which is something uniquely moving: when the prints were exhibited at a gallery in Granada, Spain, viewers openly wept.

Young British Artists Jane and Louise Wilson—nominated for the Turner Prize in 1999—used themselves, their sisterhood and their identical 'twinness' as subjects throughout their work. For their degree show at Newcastle Polytechnic they submitted identical pieces: photographs where they appeared to be murdering each other; an early film showed them taking LSD for the first time. Their 1995 piece, *Normapaths*, featured stunt doubles of the twins walking through fire and breaking down doors.

From the seven daughters of the Titan Atlas in Ancient Greek mythology to the romantic protagonists of *Little Women*, *Pride and Prejudice* and *Sense and Sensibility*, and the feminine wistfulness of Sofia Coppola's sisters in her film *The Virgin Suicide*s, it seems sisters and their bonds have been fascinating to us since the beginning of time.

Here, photographer Sophie Harris–Taylor has captured some of what makes sisterhood so captivating—through both portraiture and interview—demonstrating the deep-rooted jealousies, fears and love that co-exist between sisters underneath their initial exteriors. And it's not just a creative experiment for her—it's something far closer to home. Sophie's own sisterly relationship has always been a tempestuous one, ultimately leaving the pair at some distance from each other. As such, she's been trying to find the secret to a strong connection through her work.

Despite each individual woman photographed and each relationship portrayed being unique, common themes have emerged during the project: trust, jealousy, memory, loss, as well as often-fraught teenage years (especially for those close in age), fierce protectiveness and unconditional love. Many of Sophie's subjects speak to their sisters with no filter—with a degree of honesty they don't

even have with their closest friends—
but, despite this, rarely ever really cause
their relationship lasting damage.
She also found that, in difficult times,
sisters will almost consistently put aside
their differences and stick together, act as
each other's emotional crutch.

This is backed up by psychological
studies into sisters: Buhrmester and
Furman (1990) found a greater intimacy
and companionship with sisters than
with brothers, and psychologist Robert
Williams has identified the relationship
between sisters as being both the closest
and most competitive. A study published
in 2006 in the journal *Child Development*
analysed interviews with 200 families,
and found that sisters feel closer to their
siblings than brothers do.

Sophie's unflinching, unsentimental
style reflects her desire to unpick
this complicated reality of sisterhood
completely, not simply selecting the
palatable, easily swallowed parts.
She exclusively uses natural or available
light, which adds an honesty to the
images, creating a greater connection
with the viewer. Here we see as many
pensive and weary looks—and defensive,
sometimes challenging ones, straight to
camera—as we see loving hand-holding or
protective arms draped around shoulders.

The viewer is planted in the sisters'
private spaces—bedrooms, living
rooms, gardens—which allows Sophie
to show them at their most truthful.
We are invited to take a glimpse into
their relationships, but only from the
edge of the threshold, we're not allowed
entirely in. They're not asking to
be found beautiful or pleasing;
we should count ourselves lucky to even
snatch a glance.

"In all my work, I hope that people will
be able to relate in some way or another,"
Sophie says. "Perhaps it will resonate
if you have a sister more, but I would
hope that any viewer will find some
aspect meaningful. That might be the
importance of certain ages, womanhood,
or experiencing unconditional love.
Ultimately, I hope it might result in the
viewer placing a little more value on
their own relationships."

Above all, these daring, stripped-back
images are about holding up a clear,
bright mirror to sisterhood in its
wonderful weirdness, warts and all.
Any woman with a sister will
immediately connect with and relate
to the emotions in these pages—good or
bad—and anyone else will no doubt
wish they understood this most complex
and nuanced of human relationships.

Emma Finamore, London, 2017

PHOTOGRAPHER'S NOTE

This is for sisters. Sisters of all ages and backgrounds, sisters who are close and sisters who have their differences. I want to thank each of the girls and women I met—those who cried and laughed and shared their experience of being a sister and the complexities that lie with that. This book is a celebration of sisterhood, in all its glory and all its flaws.

This project began from reflecting on my own relationship with my sister. Over a number of years I have felt a pressure to conform and have a kind of relationship that, for so many reasons, hasn't come naturally. Ours is a tempestuous one, one that has ultimately left us at some distance. I wanted to question and explore this through the eyes of other sisters. I thought that, perhaps by doing this, it could bring the answers for my own flawed relationship.

Sisterhood is, of course, a lifetime relationship. These photographs, however, by their nature, are of a moment in time. This is true in their creation as well as their result. Many of the sisters found real value in spending a little time in each other's company, together, in silence, only reflecting on their relationship. I wanted to strike the balance between expressing their collectivity and individuality, the images sitting somewhere between snapshots and more formal portraits typically seen of families.

The accompanying interviews were equally important. For most, some of the questions I asked were difficult— they struggled to find the words. Trust, jealousy, memory, loss, petulance and unconditional love ebb and flow between their past and present relationships. The adult sisters most often have had to rebuild their relationships, however (and perhaps this should have been obvious), the formative childhood years always seem to be the basis. I was certainly able to relate to, and reminisce over, the sisterly squabbles—be it over clothes, sharing, and who's allowed to stay out the latest, or the seemingly unforgivable things we may have said to each other.

I don't know if I've found all the answers I was looking for, but what I have certainly learnt is that a sororal relationship is like no other, often taken for granted and overlooked. Despite most sisters here being relatively close, they admit that, even for them, it's not without its flaws. However, each endures, a continual presence, a shared anchor point and the last place they can turn.

Sophie Harris–Taylor, London, 2017

SOPHIE HARRIS-TAYLOR

HOXTON MINI PRESS

Sophie Harris-Taylor is a fine art and portrait photographer, born in 1988 in London. Renowned for her images created exclusively with natural and ambient light, her work centres around relationships and the everyday moments shared between people in familiar, but often mundane, surroundings. Harris-Taylor has previously been nominated for the Taylor Wessing Photographic Portrait Prize, The Renaissance Photography Prize and The Young Masters, and her work has been featured in numerous international publications. This is her second photography book.

Hoxton Mini Press is a small but award-winning independent publisher based in East London. They make collectable photography books focusing on niche subjects and human stories. As more of the world goes online they believe that books should be cherished as beautiful physical objects that earn their place on well-managed shelves and are passed down through generations. Hoxton Mini Press was started by Ann and Martin, and their two dogs, Moose and Bug.

AMBER

PHŒBE ANNABEL

Annabel	I'm not uptight.
Phœbe	You're the most uptight person I know.
Amber	You are very uptight.
Phœbe	Don't get so uptight about it.

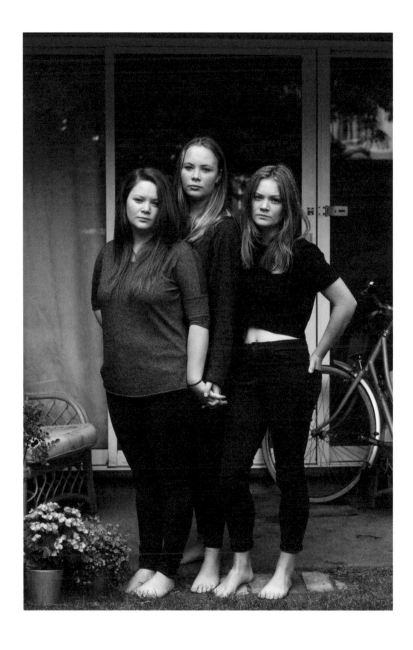

EVE

LOLA

Eve When I was going to get my hair cut Lola
went ballistic and said she wanted her
hair cut but she actually didn't. She really
wanted to be exactly the same as me.

Lola That was five years ago.

Eve No, it was two.

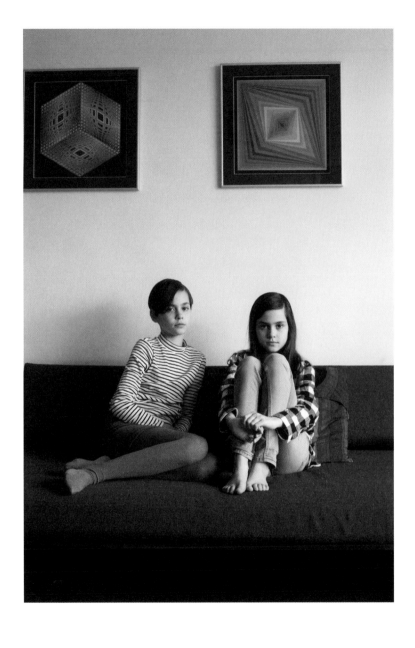

ANNE
MENG

Meng I was always jealous of her.

Anne I was never jealous of you.

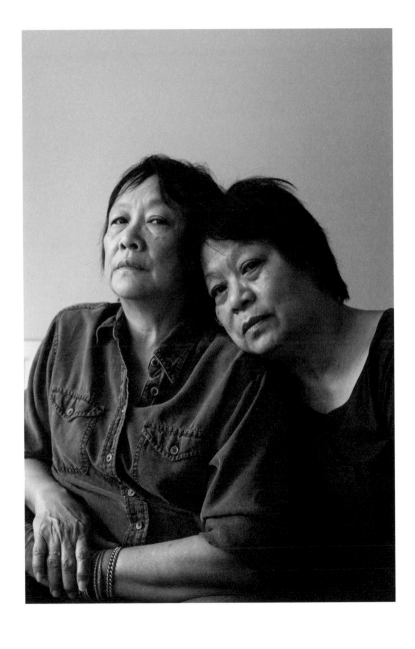



GRACE

JESSIE

Grace She's so young, she doesn't really have
 any personality yet.

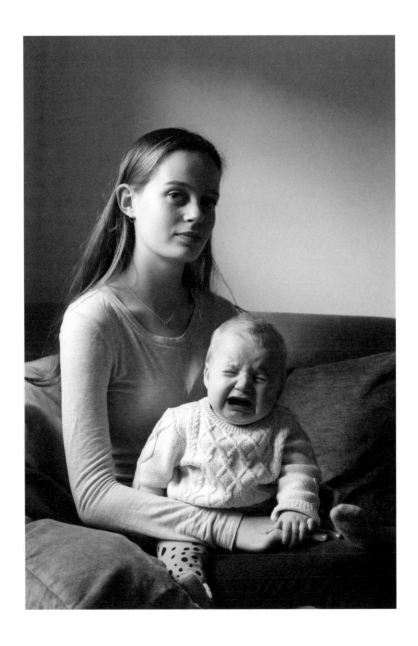

FLO MILLIE

CLARA

 CECILY

BEA

 OKI

Bea I'm having seven children and three dogs
and a cat and two fish and a hamster,
but I also might want to adopt children.

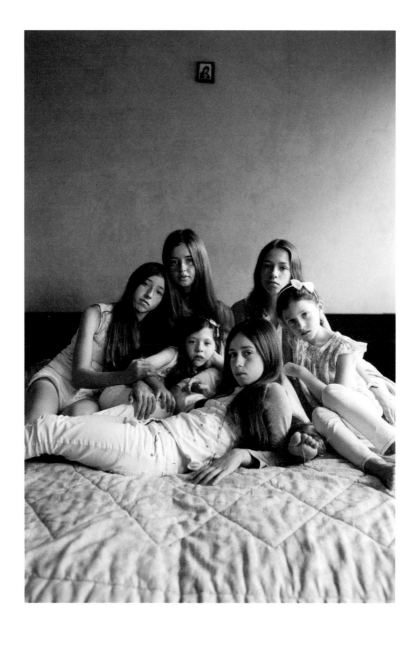

KATIE LESLEY

Lesley When you're a twin you don't look at that
 other person and see yourself. You see a
 sibling, someone who is as individual as
 you are and entirely different.

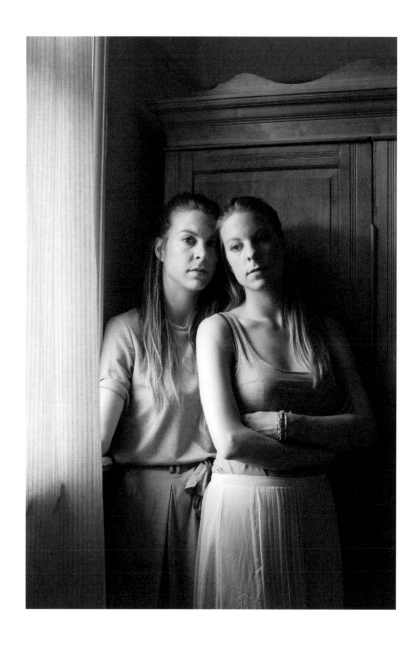

NIKE

LIV

Liv I don't want her to go when she grows up.

Nike But she always says, "When you leave
I want to get your room, your books and
your clothes."

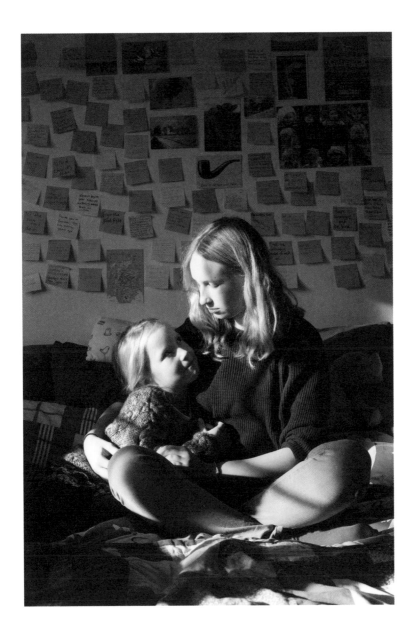

CLARE JULIET

Clare You're very helpful and kind.

Juliet I thought you were going to say, "She's an old boot."

Clare Shut up.

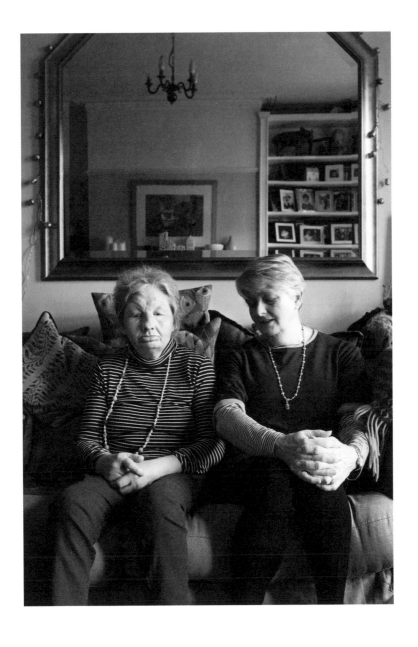

ALICE

FLO

Alice Flo brings me perspective. Without
 her, I would find my life a lot harder.
 I feel like sometimes I'm not great at
 knowing my own mind, and—it's
 such a cliché—she often knows me
 better than I know myself.

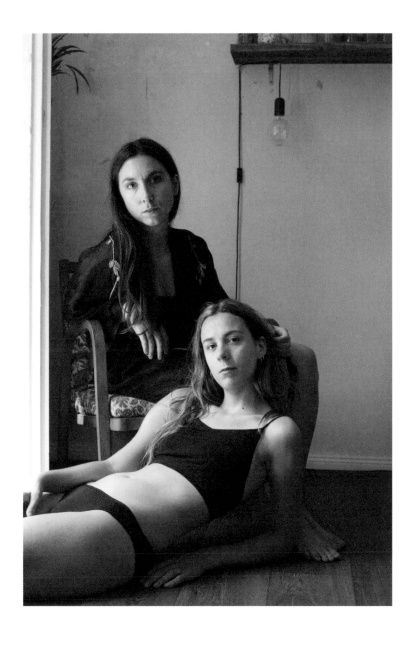

COCO

MIMI

Coco	She likes to be the same as me.
Mimi	I sometimes call Coco, "Mimi".

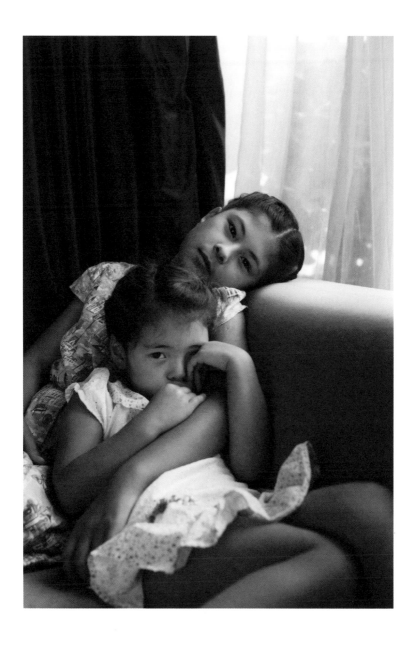

TAMSYN

MARTINA

Tamsyn I'm an open book but I don't know
everything about Martina's life.
She's very closed and has secrets. I don't
know what secrets, of course.

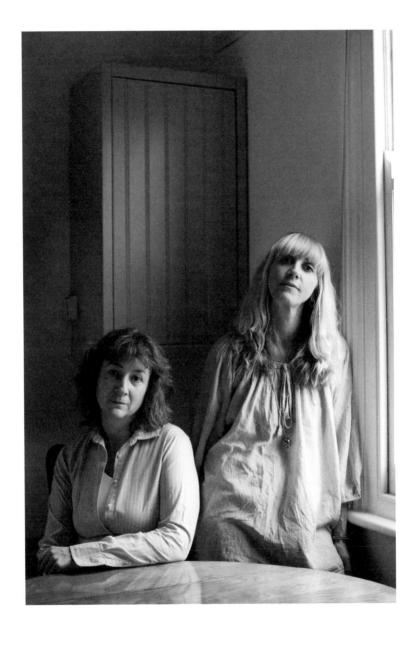

ANNA

KATE

Kate I'm envious. But not in a negative way.
 I think Anna is so ridiculously talented
 and beautiful, and I'm quite jealous that
 she's taller than me and has more freckles.

Anna It's exactly the same for me—envious—
 because Kate's the better looking, more
 talented, brainier achiever of the family.

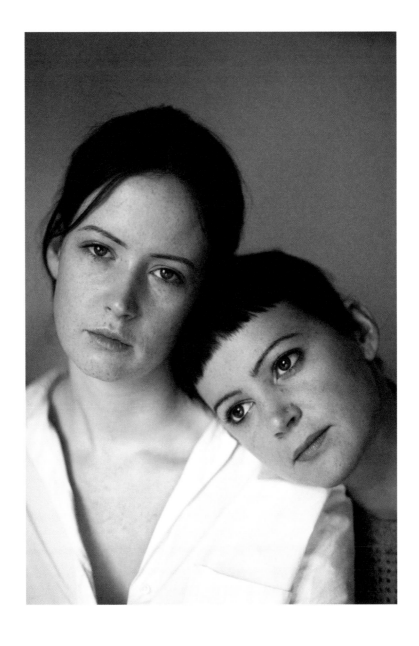

RHIANNE

ANAYA

KIANNA

SIENNA

Rhianne I don't like cheese and tomato, and they
all like cheese and tomato.

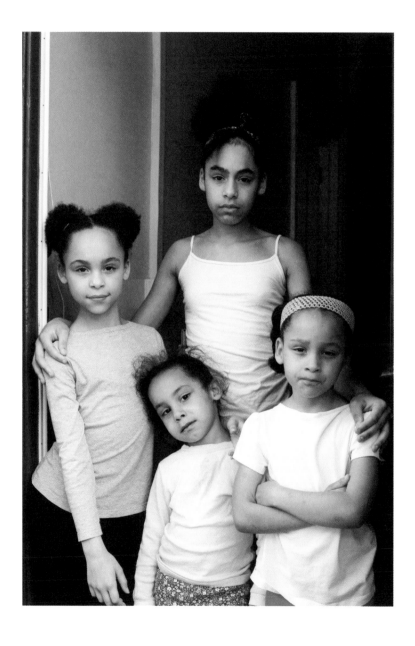

ANDREA

VANESSA

Andrea
I was always slightly more extroverted growing up and Vanessa more introverted. Together we are like one good daughter.

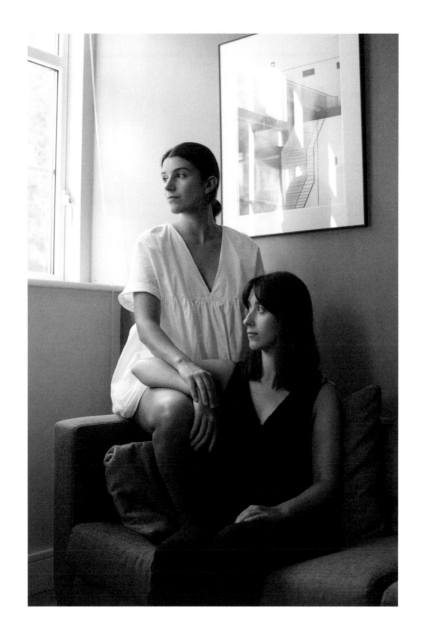

TILDA RUBY

ERIN

Tilda We are open with each other, but there
 can be a lack of openness sometimes.
 All of us can be quite closed-off and that
 seems to be a common theme.

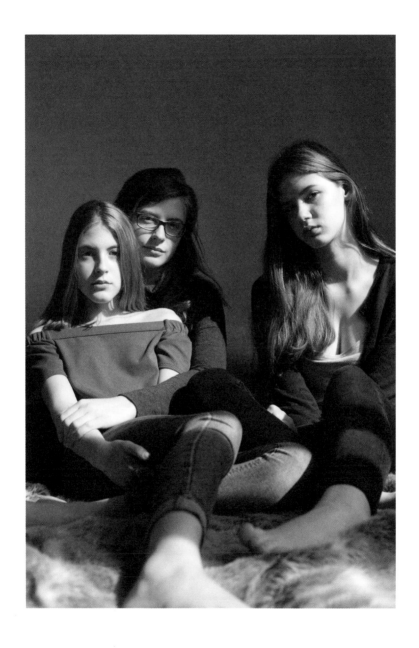

RACHEL MICHELLE

Michelle When we speak about having children, my
husband only wants boys. He says, "I
don't mind one girl", and I've always said,
"No, you would have to have more than
one girl because every girl needs a sister."

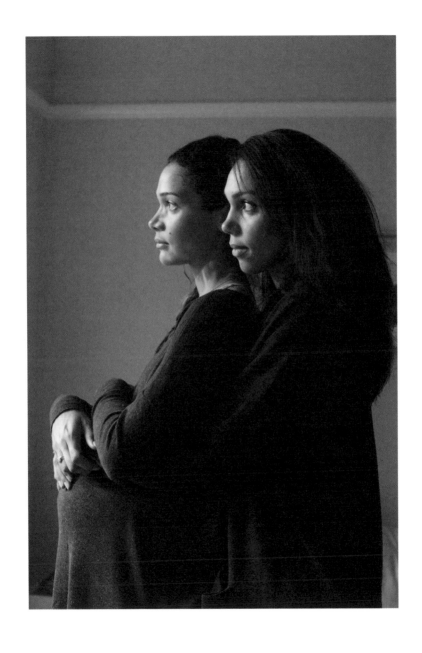

LIZZIE

FLO

Flo I'm probably more happy and
 comfortable in Lizzie's company than
 anyone else's.

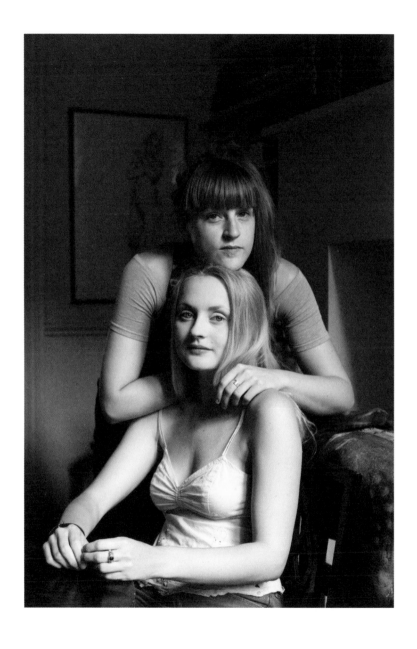

DOLLY ANNA

Anna We always make up after an argument
because according to the Bible
you don't sleep without your sister.
We can do that especially now that
we're both Jehovah's Witnesses—
you don't sleep until you've made up.

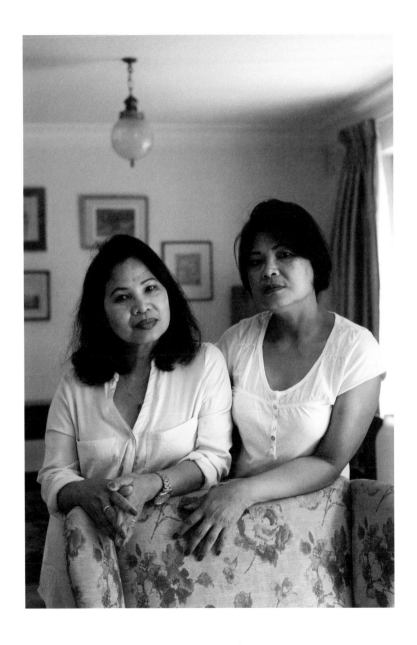

FREYA GEORGIA

Georgia I always wanted a younger sister and I was begging Mum, "Please, please have another one?"

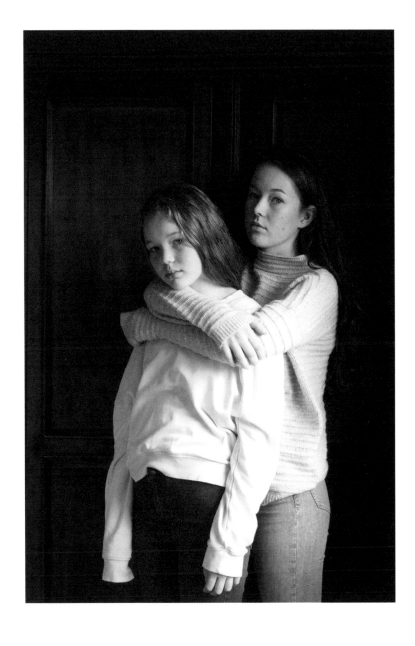

IMOGEN

SARAH

Imogen	When we were little, there was a sweet shop down the end of the road where we lived. We used to get 10p on Saturdays and were allowed to walk to the shop on our own to buy sweets.
Sarah	I would eat all my mini Mars bars in a day, easily.
Imogen	Yes, and then I would have to give her half of mine. I never learnt, did I?

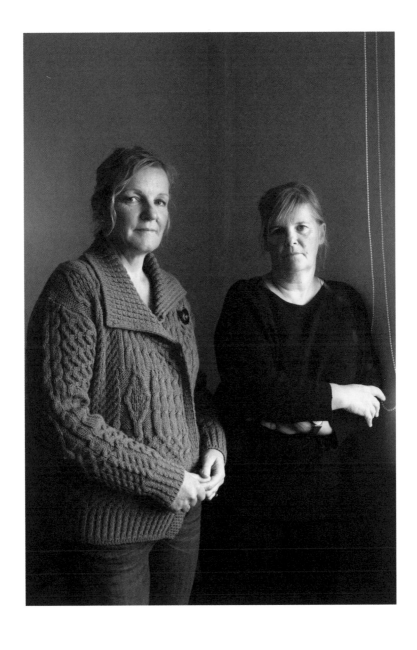

JOY
BOWY

BELLA

Joy

I argue with them when they do something
stupid: not listening to our parents,
not being nice to our parents and not
appreciating what they do. I remind
them that I know their point of view,
I know why they do it. But Mamma's
always there for us, so don't be too hard.

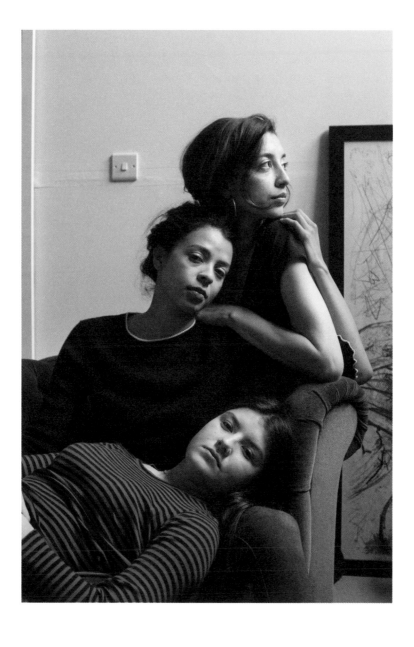

HATTIE NICOLA

Hattie You were the experiment child.

Nicola Well, you always are when you're the
 oldest, aren't you?

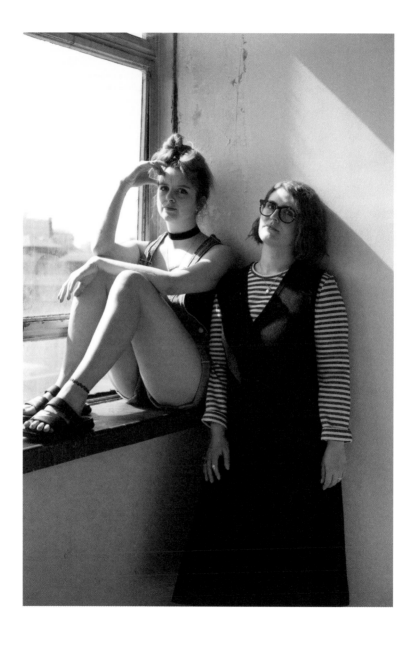

ZITA UNITY

Unity Sometimes, if I'm angry, I can talk to
 Zita really fast because she will
 understand. We read each other's minds.
 I know exactly how she's thinking.

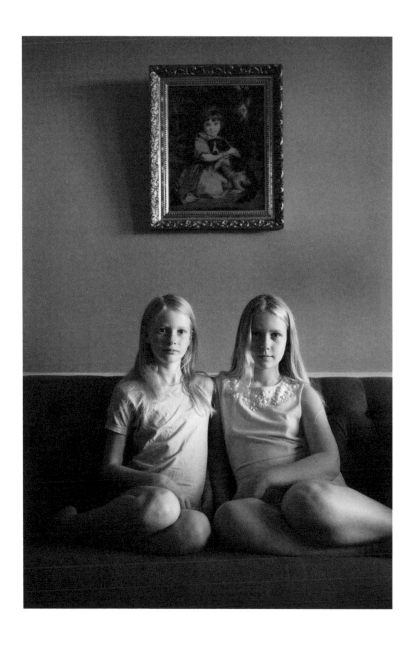

SAM VICKY

Vicky We've talked about moving out of London
but I don't know if I could do that
because I wouldn't be near to her. It would
be weird.

Sam We will be in an old people's home together.

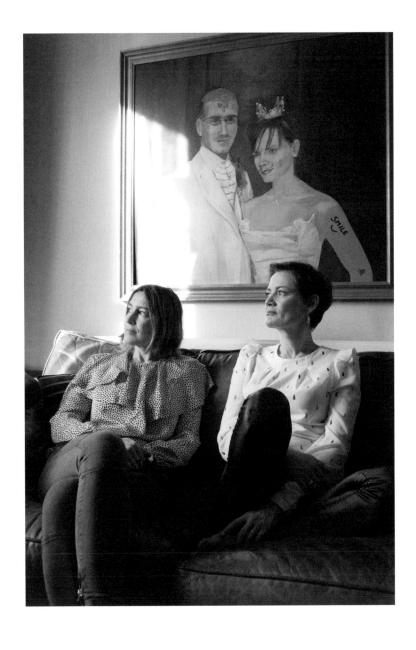

LEXI

ELLIE

LORETTA

LILY

Lily I call them "grandmas" all the time. I
send them grandma emojis.

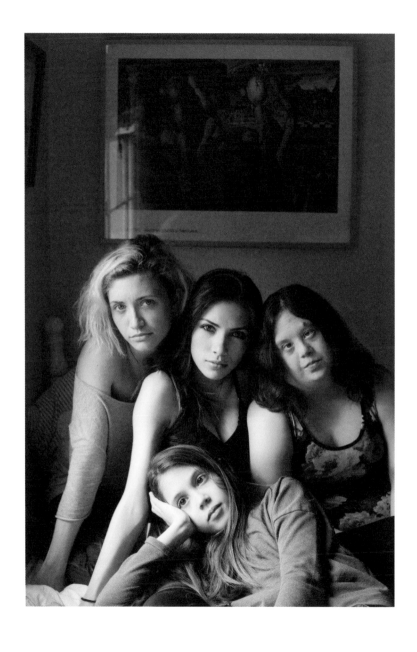

FREYA KATHLEEN
THEA

Kathleen Sometimes I'm first but it's very rare.
If it's, "Who wants the first pancake?",
I'm always second because it's always
oldest to youngest or youngest to oldest.
It's annoying for me because I'm the
"Middl'n". That's what our dad calls us:
"Littl'n", "Bigg'n" and "Middl'n".

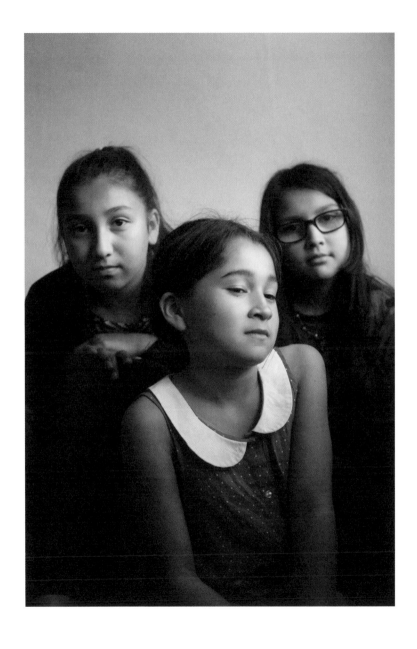

SOPHIE ABIGAIL

Abigail I was just really upset that you got engaged.
I was a moody teenager and I take it
back. Maybe I was jealous. I think I felt
like I had lost you.

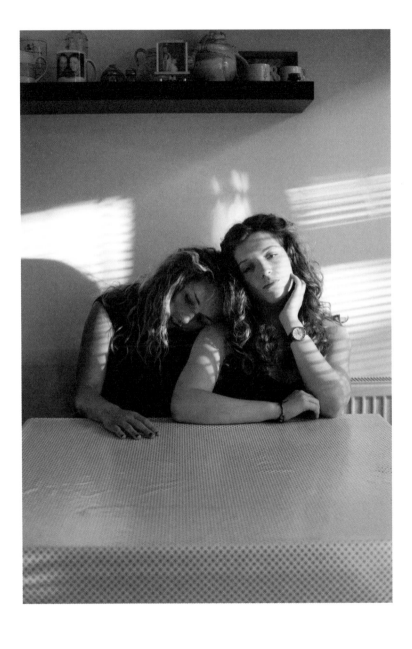

TESSA

FRANN

Frann I don't think we argue anymore. Actually,
I don't think we argued until I was
10 and Mum got us a Nintendo with one
controller.

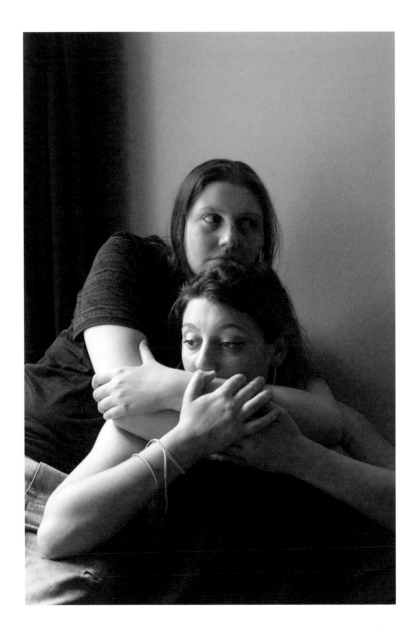

JO JESS

Jess	We were fundraising for Amnesty International, campaigning for peace and gay rights—you were 18 and I was 19—and we got really, really drunk.
Jo	And some guy came up to us and was like, "2-for-1 tattoos".
Jess	So we thought we might as well. We went to the pub for a couple of drinks and we were just like, "Fuck it".

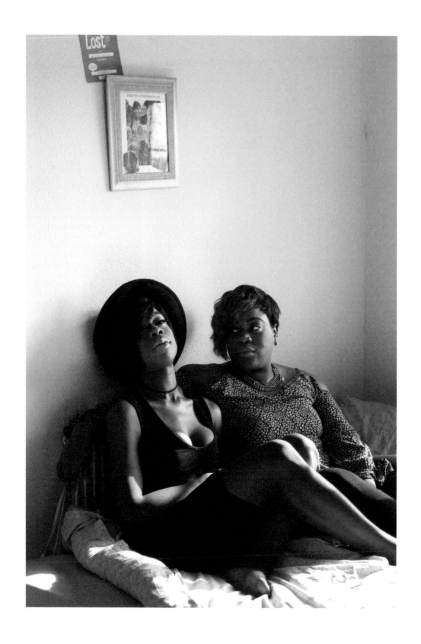

BETH FRANKIE

 CHARLIE
FLO

 TUESDAY

Flo You can't tell one sister something and
 trust that sister not to tell another sister.

Charlie There's no secrets between us. There's no
 secrets at all.

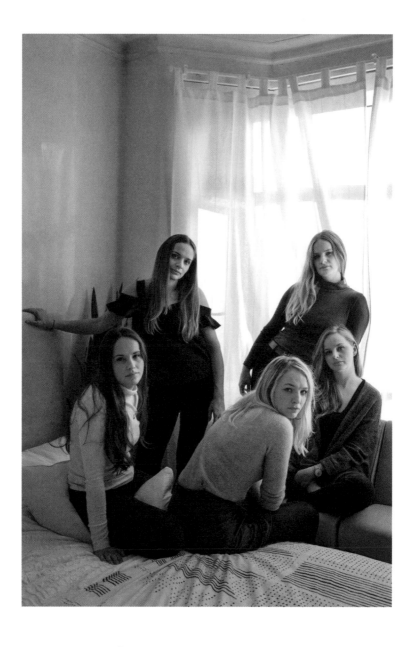

SARAH

HATTIE

Sarah Even though I'm older, I often felt like the
 younger sister because Hattie got married
 before me and had children before me.
 Hattie is a granny too, so in many ways
 I sort of follow on behind. All in all,
 I don't consider myself the older sister.

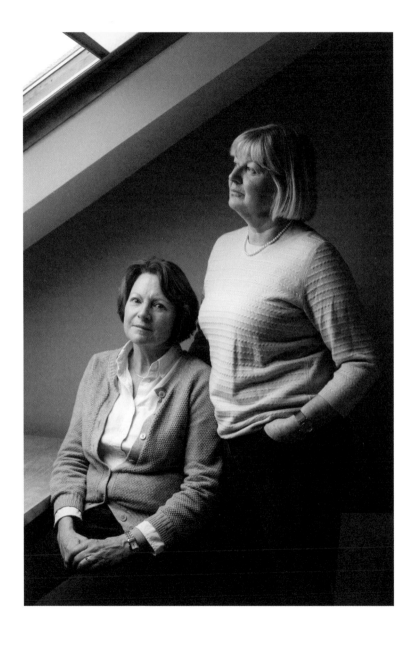

CLARE
AMY

Clare

Eighteen months is hardly anything, so
when we were growing up I saw Amy
more as a rival. It probably wasn't until I
left university that I got very protective
over her. That was the first time that we
weren't together in the same place.

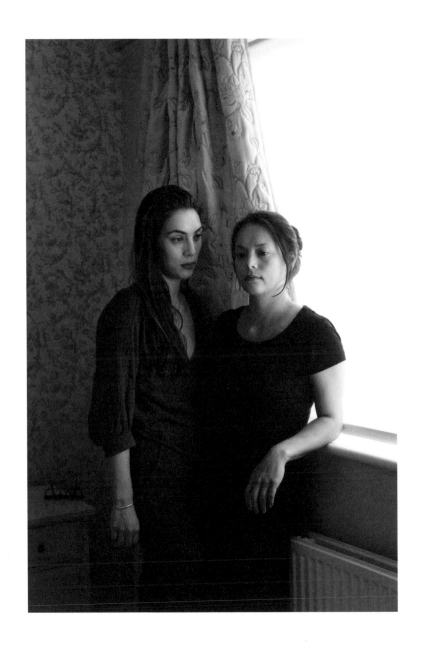

JASMINE

ALLY

Jasmine I sleep on the top bunk. I like it—we don't
 talk, we just go to sleep.

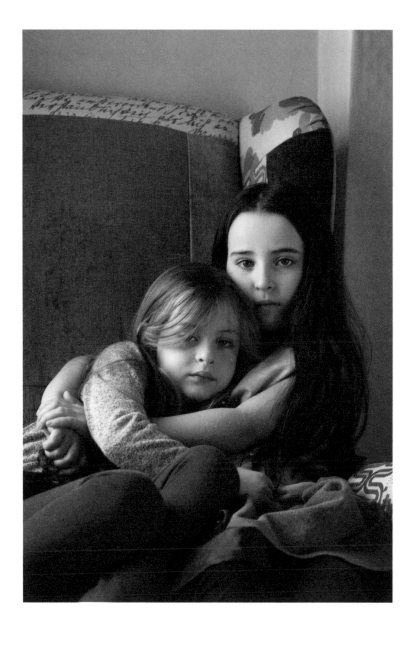

CHARLOTTE

DEBORAH JULIET

Charlotte I think our differences come from the
schools we went to. Deborah and
our brother Ben both went to private
schools, proper schools, and we just
went to normal comprehensives.
I honestly believe that, I think it's an
environmental thing.

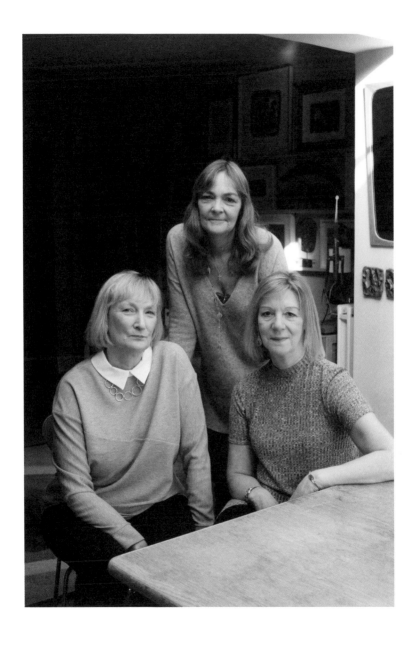

ROCHELLE

SABRINA

Rochelle Literally every Monday we would meet
up and set the world to rights, and catch
up and have a moan and a cry. We'd have
a week's worth of sisterhood in that time.

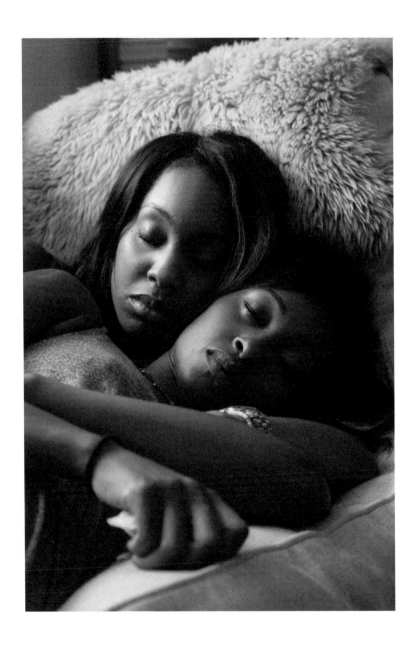

EVIE-MAY COCO

Evie–May I remember this one time when my
friends came round for a sleepover, they
spent an hour or two just playing with
Coco and not me. I felt so left out because
you took my friends away.

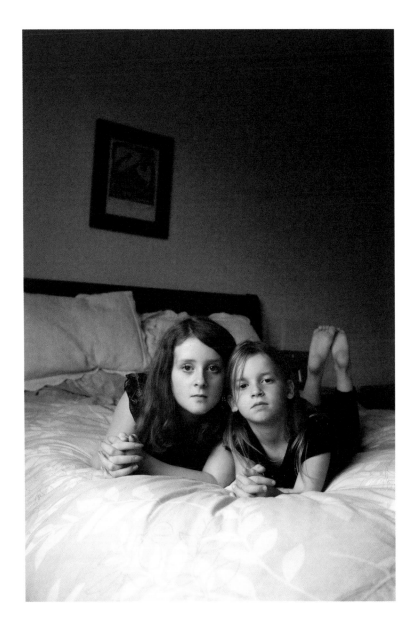

LINDA DIANE

Linda	Diane thinks she's always right.
Diane	Linda thinks she's always right.

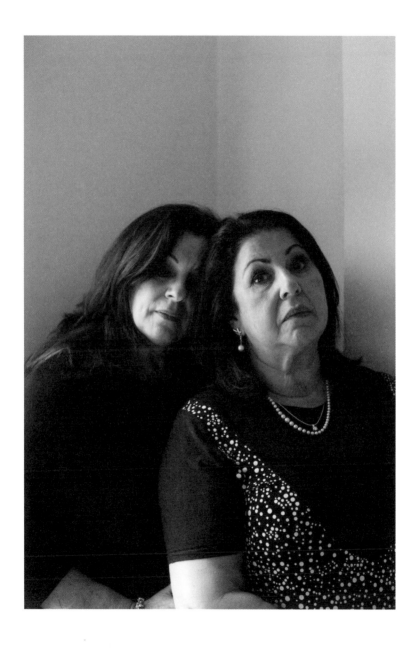

RIYA

AMBI

Ambi There was a turning point when I realised
Ri was actually my sister, not just
someone I looked after. It was when she
kept my first secret, when I was 16 or
17. Ri walked in on me sleeping with my
first boyfriend.

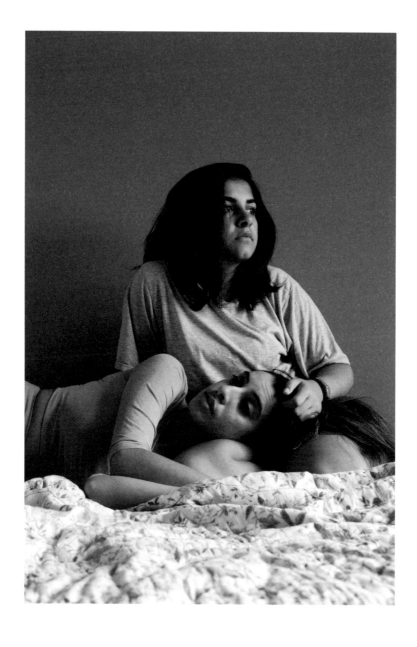

IMOGEN

BASTIA

Imogen	The name change is actually really recent, pronouns are really recent, but I always thought of her more as a sister. I used to call her my sister in a friendly way, like, "Hey sis".

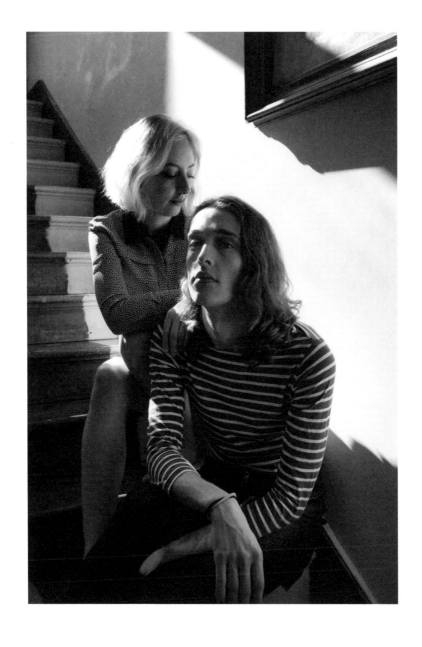

KEIRA OLIVIA

Keira I bore the brunt of the trouble, so you
 didn't really have to.

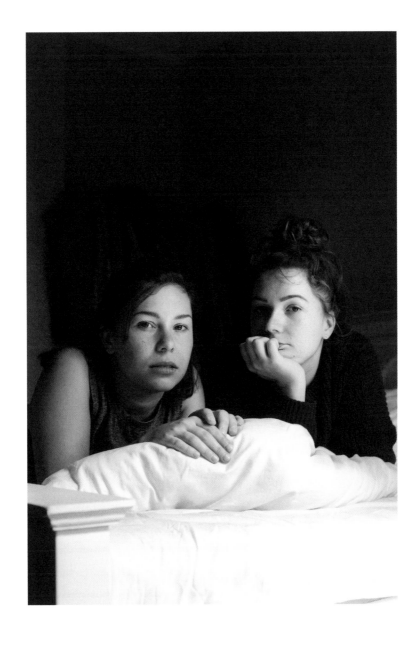

HOLLY

ZOË

SUZIE

Holly We are close but we wouldn't
necessarily go to the same party and get
really drunk together.

Zoë I would find that really awkward.

Holly We wouldn't talk about sex with
each other, but some siblings are really
close and do that.

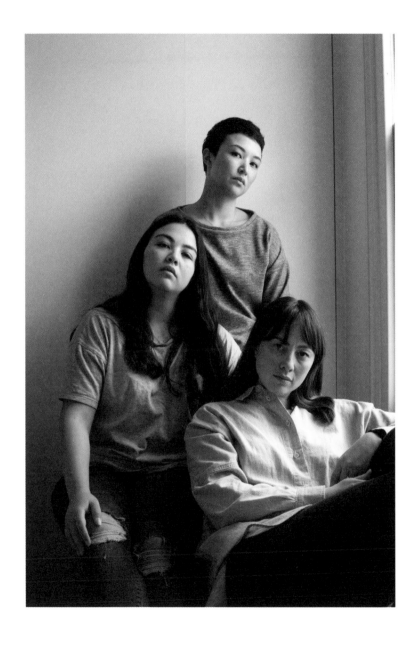

GRACE
EVE

Grace	We used to walk our dog and you would have a fag and I would be like, "Oh my god, she's having a fag, I can't tell anyone this."
Eve	And I would be like, "You're not allowed to tell anyone I'm having a cigarette, and if you tell Mum, I'll kill you."

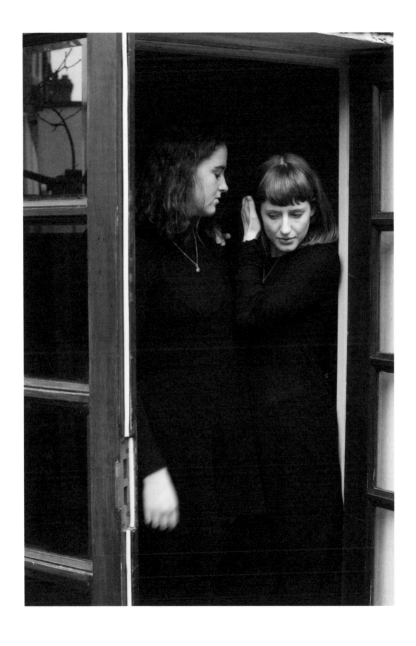

STORIES
Compiled by Emma Finamore

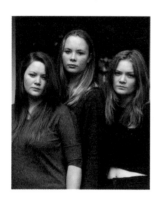

8

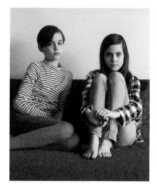

10

PHŒBE [22], AMBER [17], ANNABEL [22]

Amber and Annabel are living together and it's a rocky relationship—in fact, they were actually arguing just before this photo was taken. The twins don't fight and there's no jealousy between them, even when Annabel got a boyfriend first. As the non-twin, Amber can feel left out. The three used to play a game when they were little—wrapping themselves up in duvets and running at each other— but Amber was so much smaller than the twins that she spent most of the time on the floor.

EVE [11], LOLA [11]

Two thirds of triplets with their brother, Lola and Eve are very different. Eve's a good leader—she's head girl at school— while Lola's quieter and more thoughtful. Sometimes they want to get as far away from each other as possible, but their relationship is stronger than with their brother—because they're sisters, they say. After a fight they don't say sorry, they just start playing a game and forget it ever happened.

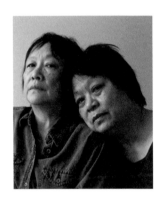

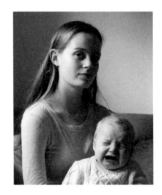

12

14

ANNE [62], MENG [61]

GRACE [17], JESSIE [8 months]

Growing up in Malaysia, Anne was a mini-skirt-wearing rebel in matching knickers like her heroine Twiggy, running around with a gang of boys, riding about on baby cows, making catapults and toy guns, while Meng stayed home being good. Anne's rebellious streak got her sent to an English-style boarding school, escaping the chores that Meng—educated in the Chinese system—was responsible for in the family home. The contrasts continued into adulthood, but they're closer now despite their differences.

This is a very new relationship: Jessie is just eight months old. Grace was an only child until three years ago when her little brother (Jessie's older brother) was born, and she thinks this has given her the best of both worlds: now she has the fun of experiencing siblings—and they'll never have to fight over toys. Grace already thinks her brother is like her, while her baby sister is more laid-back.

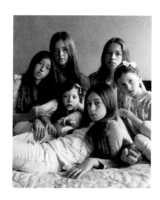

16

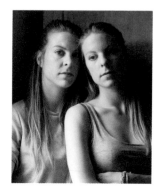

18

CLARA [15], FLO [20],
MILLIE [16], CECILY [8],
OKI [11], BEA [6]

This big group of sisters (with three
brothers too, so there are nine siblings in
total) has formed smaller groups within
the unit. Often the youngest two are best
friends, and the teens team up. Flo and
Oki call themselves the "holding forces",
bridging the gap between the youngers
and elders, while Flo supports everyone
as the oldest. She spends long stretches
away from home on tour as a musician,
which can be painful: Flo misses out on
seeing the youngest grow up, while
they all wish she could be around more.

KATIE [27], LESLEY [27]

Being identical twins as children could
be frustrating, these sisters say,
as they fought for their own individuality.
Katie recalls a time when they hadn't
seen each other for eight months (Lesley
had been in Australia) and she got an
insight into how others view them:
she suddenly realised how "identical"
their voices and mannerisms were.

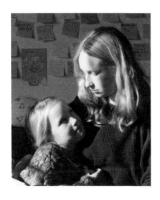

20

LIV [6], NIKE [16]

Nike only had brothers until Liv came
along when she was 10 years old,
so she was especially happy to have a
sister. Liv is creative—always drawing
and making—confident (having
three noisy older brothers meant she
had to find her own, loud voice early on)
and caring—she even won the school
prize for kindness. Nike is much quieter,
but they share a love of books,
and Liv likes it when Nike babysits her.

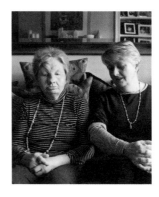

22

CLARE [55], JULIET [60]

These sisters have had very different
lives. Clare has struggled for
independence in spite of a disability,
while Juliet has had to support the
whole family (at least that's how it feels)
including their other two sisters.
Clare was sent to boarding school when
she was seven and was terribly homesick,
but the two still share some childhood
memories like taking the blue pram
out for a walk with their dolly called
Pixie and going to the corner shop
for ice cream. Juliet admires Clare's
strength, even if she doesn't always
answer the phone.

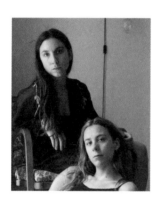

24

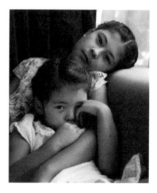

26

ALICE [27], FLO [21]

MIMI [4], COCO [9]

Alice and Flo were close as children but often clashed when Alice was a teen. They say they had to re-learn their relationship in early adulthood. A six-year age gap meant their formative years were very different: when Alice was 13 she had two parents and a little sister, for example, and when Flo was 13, she was basically an only child—her sister had already left home. Nowadays they're very close, best friends even, living together, and Alice still feels the need to look after her little sister.

Though they might argue about sharing things and sometimes interrupt each other's play dates, Mimi and Coco are pretty good friends. In fact, that's how they usually make up after a fight: Mimi will ask if they can be friends again. They love sharing a bedroom because at night they can go mad and chat until the small hours, and jump around. Mimi will also get into Coco's bed when she's had a bad dream about the scary creature coming up the stairs.

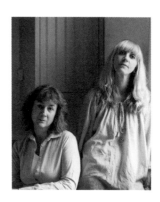

28

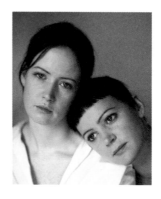

30

MARTINA [49], TAMSYN [48]

ANNA [28], KATE [37]

These sisters went to different schools, had different social groups, and behaved very differently. Tamsyn was out all the time, smoking and drinking, while Martina would stay in at the weekend and read books. She's also more private than Tamsyn, but they go to the theatre together a lot and have the same sense of humour. They can always count on one another to get each other's jokes.

Almost 10 years apart, these two live far apart too—Kate in America and Anna in London. Growing up, Anna was wrapped up in cotton wool and close to her parents, while Kate was more independent, the black sheep of the family. Nowadays, Anna is the social butterfly; Kate can be more socially awkward. The rare time they do manage to spend together is pretty intense, but it means they value it all the more.

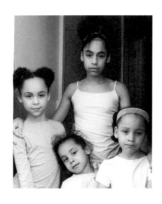

32

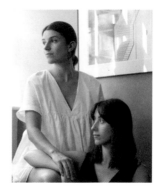

34

RHIANNE [14], SIENNA [6], KIANNA [4], ANAYA [11]

The youngest two in this group are self-proclaimed opposites: Sienna is a tomboy, into cars and Xbox and climbing trees like a monkey, while Kianna is a girly girl. With four brothers as well, Rhianne sees herself as in the middle. She and Anaya aren't keen on sharing a room, except when they can't sleep at night.

ANDREA [23], VANESSA [24]

Despite growing up like twins due to their closeness in age, Andrea and Vanessa say they're different in every way: Andrea the naughty one, and Vanessa the good. They are growing more similar with age though—they even live together now—and recently started running together, supporting each other through a 44-mile ultra marathon. One characteristic they definitely share is their sense of humour: they'll often both get tickled by the same thing and end up crying with laughter, on the floor.

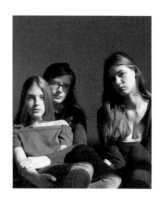

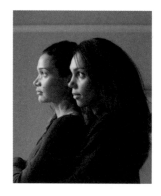

36 38

ERIN [11], TILDA [20], RUBY [15]

People often comment on how relaxed
these sisters are with each other and
how similar they are—maybe because
they've all been home-schooled—
but they do argue, most recently over
stealing each other's clothes. Tilda gets
very sentimental about Erin because
she was nine when she was born and
remembers helping out with her at home.
Erin likes the fact that she gets two
different opinions when she needs
help, and is the most maternal despite
being the youngest.

RACHEL [27], MICHELLE [31]

Despite both being quite quiet, Michelle
and Rachel speak to each other daily—
sometimes hourly—via FaceTime,
text, WhatsApp or Instagram. They both
live with their husbands now but still
socialise a lot and love to travel together.
They reminisce about their crazy
trip to Las Vegas, or a time in Ibiza when
Michelle remembers a scorching hot
walk back from a tiny beach, with their
hair big and curly from sea and sunshine,
giggling as they went.

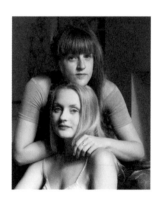

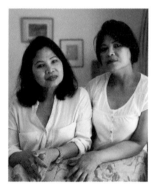

40

42

LIZZIE [26], FLO [21]

DOLLY [50], ANNA [49]

Lizzie and Flo lived alone without their parents for four years when Lizzie was in her late teens/early twenties and Flo was a teenager. This meant growing up quickly, and Lizzie taking on the responsible, parental role as much as she could. Flo idolised her older sister— even her smoking—and the pair have ended up with very similar mannerisms: sometimes it can feel like talking into a mirror.

Anna and Dolly grew up together in the Philippines, and when Anna first came to London alone they maintained their closeness via phone and Skype. These sisters have similar tastes but are very different: Anna is smiling and friendly while Dolly—the eldest— is strict and quiet. They share a religion though (Jehovah's Witness) and Dolly always helps the more troubled Anna, which is easier nowadays: she lives next door rather than on a different continent.

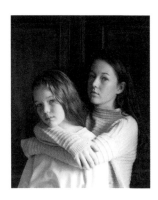

44

FREYA [11], GEORGIA [16]

Like many sisters of their age, these
two have a love-hate relationship.
Freya steals clothes from Georgia's room,
and when Georgia has friends over she'll
hang around wanting to join in the
fun, which causes arguments. Their rooms
are next to each other, though, so they
often talk and do nails together; and when
Georgia goes away they stay in touch on
Instagram—Freya misses having someone
to talk to in the car.

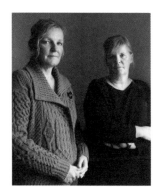

46

IMOGEN [52], SARAH [54]

When they were children, camping in
France, Sarah and Imogen were often left
to their own devices, and would go off
swimming and playing. One day Sarah
was skimming a pebble on the river
and accidentally hit Imogen—who still
has the scar—and they lied about what
happened so they would still be allowed
out on their own. Despite being in
touch, they don't see each other much
now, but there was a time when they
lived next door to each other. This was
perfect, they say.

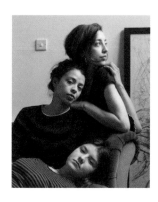

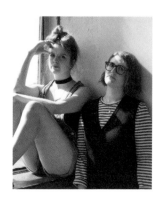

48

50

JOY [27], BOWY [26], BELLA [19]

HATTIE [28], NICOLA [31]

While they live in different countries—
Bowy in the UK, Bella and Joy in
Holland—these sisters are very much
a unit. Joy has a motherly instinct:
their parents divorced when she was 11
or 12 so she helped their mother take care
of their "little lion cubs" from a young
age, and loved it. Bella is always seen as
the little baby—cool and carefree—
while Bowy in the middle is very open-
minded and spiritual, according to
her sisters. These three don't gossip about
each other—they get everything
out in the open. Very straightforward,
very Dutch.

When Hattie was born, Nicola was
obsessed with her new baby doll.
During Nicola's teen years there was
petty clashing—Hattie would steal
her lipstick and Nicola would come
into her room "like a fucking bull",
demanding it back. Later, things
clicked back into place and now, despite
living in different countries, they're
best buds; always the loudest and
drunkest at a party, doing the splits and
telling filthy stories.

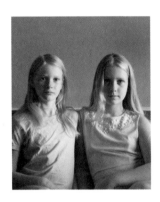

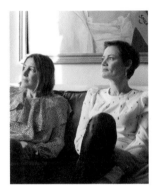

52

54

ZITA [10], UNITY [12]

SAM [46], VICKY [45]

Unity and Zita like having each other around—a sister is someone to talk to but also someone to play funny pranks on. Unity feels protective over Zita, sometimes even when her friends come over to play, but she gets annoyed when her younger sister copies her. She's also the quieter of the two, and Zita is more boisterous (at least in public) but they enjoy the same music and toys, and are very good at sharing these. They both like rollercoasters too, sharing the thrill of speeding up and down, and enjoy a good argument— as long as it doesn't last too long.

These sisters are the same star sign but have completely different personalities. Vicky is wilder and will cry at anything, whereas Sam tends not to show her emotions, except when she argued with their dad as a teenager—she always had to have the last word—and last summer on holiday, when she threw a drink in Vicky's face. They both work in PR now, so maybe they're more alike than they think.

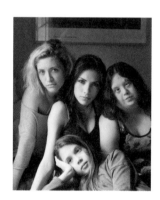

56

LEXI [28], ELLIE [20],
LORETTA [31], LILY [12]

The age difference between the older
and younger sisters in this group means
they don't socialise too much at the
moment, but growing up Loretta was the
mother hen of the group, and Lexi used
to take her younger sisters to museums
and gigs. Ellie knew all the words to
Greenday at the age of five, and Lily is
more streetwise for having older sisters.
As a group they're always the loudest
at a party, and gravitate towards the
karaoke machine. It's quite a spectacle.

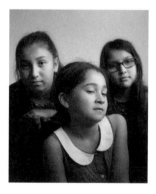

58

FREYA [13], THEA [9],
KATHLEEN [11]

Freya and Thea both dance and do
performing arts, while Kathleen is usually
drawing or reading—she used to play
dollies with Thea, but she's grown out of
that now. Despite the occasional pen-
throwing and clothes-stealing, the sisters
share a love of outdoor games, like
playing by the lake and pretending they
see a crab just to scare Thea, or jumping
over traffic cones. They find one another
annoying but admit they love each other
deep down.

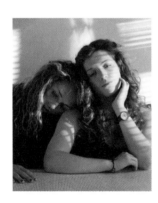

60

SOPHIE [26], ABIGAIL [20]

These sisters are best friends, and when they're together they act as if they're about six years old. The five-and-a-half-year age difference means there have been times when they weren't as close though, like when Abi was a moody teenager and Sophie had to look after her while their mother worked shifts, or when Abi was jealous of Sophie's fiancé coming between her and her sister. Nowadays, Sophie is planning on starting a family, and future auntie Abigail is excited about taking her nieces and nephews to their first music festival.

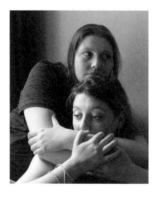

62

TESSA [24], FRANN [26]

Tessa—the quieter of the two—was a real tomboy when the sisters were little, with her Action Man toys and trousers, while Frann was a noisy, pink-loving girly girl. They didn't argue until their mum got them a Nintendo with just one controller and their differences lasted into adulthood, but they don't argue much any more and are far closer now. And Frann still holds Tessa's hand when they cross the road.

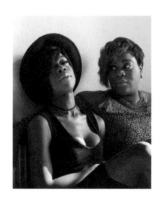

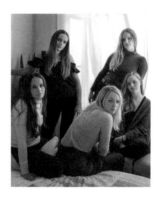

64

66

JO [24], JESS [25]

BETH [29], FRANKIE [28], CHARLIE [27], TUESDAY [25], FLO [23]

Jess and Jo are often described as "batty and bench"—a Jamaican term for two people in a very close relationship. They do everything together: holidays, parties, shopping, even matching peace-sign tattoos. Jo's the worrier, always double-checking if Jess has booked trains or flights, while Jess is the fiery one who leaves a mess everywhere— from used mugs to old false eyelashes. They've had one big fight, when they were on holiday and Jess threatened to fly back to London, but now they can't really remember what it was about.

These five describe themselves as all being crazy but different, and say all their personalities added together make up one whole person. Beth and Frankie even had babies at the same time. Flo—nicknamed "Titch"— would sometimes be left waiting at the primary school gates while the others argued outside their high school, just five minutes away, about who would pick her up. The sisters speak daily, almost hourly, covering everything from breakfast to dinner, even toilet breaks— there are absolutely no secrets here.

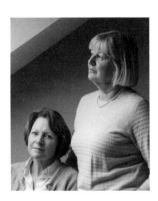

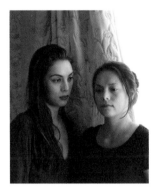

68

70

HATTIE [64], SARAH [65]

CLARE [31], AMY [29]

While they were competitive when they were younger, both sisters now have three children and that has been a great bonding force; they don't always see eye to eye but value family over everything. Hattie has always been jealous of Sarah's social life, while Sarah envied Hattie's academia, and how she settled down and started a family first. They're there for each other when it matters though: when Sarah was diagnosed with breast cancer 15 years ago, it was Hattie who dropped everything to come and help her talk to the children.

These two were often competitive growing up, sometimes seeing each other as rivals. Their mum, for example, used to put a timer on for their two hours of homework, and they'd race to see who could get the most done. They argued lots—often physically— but have fun memories too: running around outside in just their pants and shoes, and catching grasshoppers. Today Amy and Clare are close but independent—they don't talk every day, but when they do it really matters.

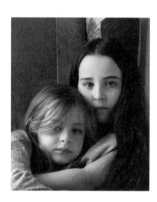

72

ALLY [5], JASMINE [6]

These two enjoy playing together—
especially dressing up and pretending
Ally is a Siamese cat—and say it feels
good having a sister and sharing bunk
beds. Despite being young they've
already made memories together,
like the time they went to the farm and
fed the lambs but not the sheep, because
the sheep were being naughty. They can't
imagine not having each other around.

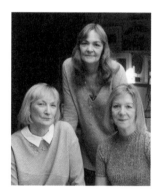

74

DEBORAH [61], CHARLOTTE [54], JULIET [58]

There's a bit of a divide between Juliet
and Charlotte and their more reserved
older sister Deborah—the younger
two are more likely to go out drinking
together, whereas Deborah speaks
more often with their younger brother.
They recall tensions when he was born
seven years after Charlotte—switching
up the sibling hierarchy—and the sad
shared memory of their father's death.
Motherhood has brought them closer,
though, and they can't imagine not being
one of three sisters.

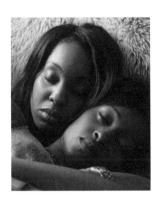

76

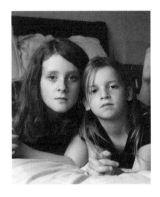

78

ROCHELLE [25], SABRINA [27]

Both chameleons, these sisters can seamlessly slot into each other's social worlds—it doesn't matter that Sabrina is a self-described mainstream Essex girl (despite being the wild child when they were young) while Rochelle, an actor, is more arty. They lived apart for a few years when their parents divorced— a shock, as they'd seemed like the perfect Brady Bunch family—but they would meet every Monday at The Windsor pub in Paddington to keep up their sisterly bond.

EVIE-MAY [12], COCO [6]

Evie-May gets protective if anyone is rude to Coco at school, but doesn't like it when Coco steals her friends if they're over to play. Evie-May always says, "No, Coco, they are my friends, not your friends", at least according to Coco. They look out for each other though, like the time Evie-May went to find Coco at the fair because she'd tripped over and hurt herself, or when Evie-May had a row with a friend when they were camping and Coco comforted her. And when Coco doesn't understand what's happening in a film, Evie-May will always help her out.

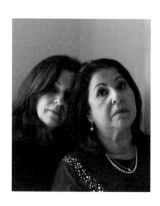

80

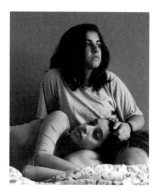

82

LINDA [61], DIANE [63]

RIYA [16], AMBI [25]

Once described as two sides of the
same mirror, these two are tightly bound
yet entirely different. They shared a
bedroom until Linda got married at 23—
sociable Diane's side was neat and tidy
while academic Linda's was a total mess.
They argue over contrasting memories
of the same incidents and annoy each
other by picking the same outfits,
but when it comes to the important stuff—
like the anniversary of their mother's
death, or the loss of their brother—there's
only one person each will turn to.

Almost a decade apart, the sisters refer
to the eldest—Ambi—as a second mum
to Riya, and to Riya as her "living doll".
Their parents had challenging pasts and
weren't around as much as those in more
traditional family units, but the sisters
had a great time growing up in their
unconventional household. It's turned
them into independent, resourceful,
sociable women, and Ambi taking
on the maternal role means their bond
is especially strong and unique.

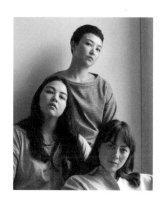

88

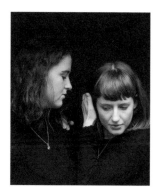

90

HOLLY [29], SUZIE [38], ZOË [24]

Despite Zoë being just three when Suzie left home, these sisters are close. They've even all lived together as adults. Suzie used to look after Zoë when she was little, changing her nappies and taking her out (people often thought she was Suzie's baby). Holly and Zoë are like chalk and cheese though, and didn't get on when they were younger—they had more of a "classic" sibling relationship, with all the ups and downs that this entails. Now, Zoë is the "insider" at the family home: if the elder two need to know anything, she's there on the ground.

GRACE [22], EVE [29]

Eve lived in a commune with her mum when Grace's dad came into their lives, with Grace following close behind. This has been a relationship of many stages: hating each other as children, having a semi mother-daughter phase, then becoming more like friends when Eve left for university. Despite jealousies and differences, they often end up at parties arguing on the same side against someone else, and both had tough relationships with their fathers. The sisters share strong political opinions and a fierce feminist streak—which they get from their mother.

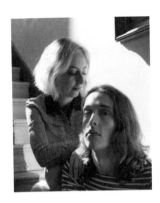

84

IMOGEN [27], BASTIA [23]

These two were not always sisters: Bastia was born biologically male. She has only recently begun medically transitioning, but Imogen always thought of her as a sister, and when Bastia came out it felt natural. Imogen is the shyer of the two, seeing Bastia's confidence as an example to follow, but they share a love of art and fashion (much of Imogen's artwork is inspired by Bastia), as well as their weird sense of humour.

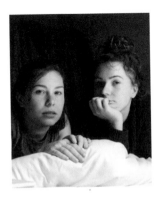

86

KEIRA [27], OLIVIA [24]

Keira and Olivia used to physically fight so badly that their mother had to intervene; these days, they live together. There was jealousy between them growing up—Olivia envied how her older sister Keira was considered the clever, capable and self-sufficient sister, while Keira envied Olivia's creativity, how she was seen as the cool, artistic one. But they always loved summers together and playing games, and there are far fewer punch-ups these days.